Masterpieces
of French Faience

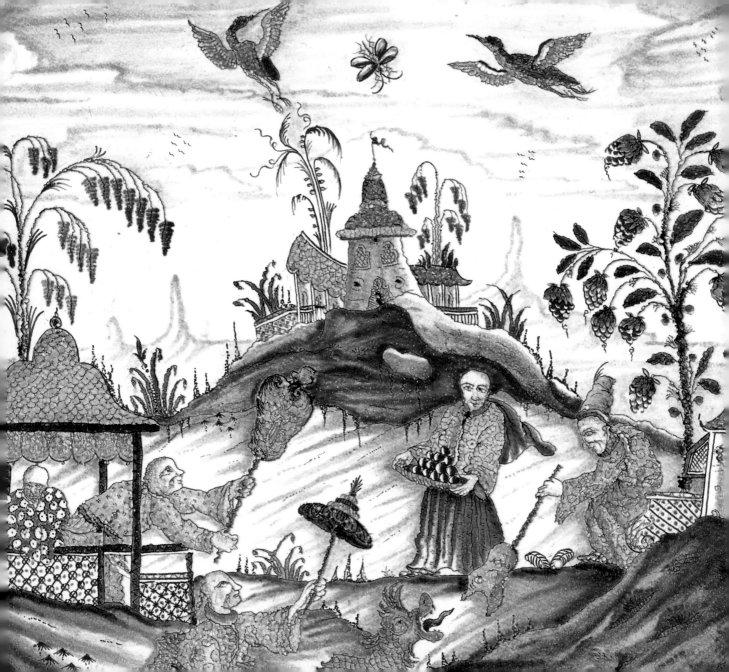

Masterpieces of French Faience

SELECTIONS FROM THE SIDNEY R. KNAFEL COLLECTION

Charlotte Vignon

with Sidney R. Knafel

The Frick Collection, New York
in association with D Giles Limited, London

g

For my daughter Lucie and all future lovers of this beautiful art form
—*Charlotte Vignon*

For Londa Weisman, my wife and favorite ceramist
—*Sidney R. Knafel*

This book is published in conjunction with *Masterpieces of French Faience: Selections from the Sidney R. Knafel Collection*, on view at The Frick Collection from October 9, 2018, through the fall of 2019. Major support for the exhibition is provided by Melinda and Paul Sullivan and The Selz Foundation. Additional funding is generously provided by Helen-Mae and Seymour R. Askin, Barbara G. Fleischman, Anne K. Groves, Mr. and Mrs. Michael J. Horvitz, Nancy A. Marks, Peter and Sofia Blanchard, Margot and Jerry Bogert, Jane Condon and Kenneth G. Bartels, Mr. and Mrs. Jean-Marie Eveillard, Barbara and Thomas C. Israel, and Monika McLennan.

Published by The Frick Collection,
1 East 70th Street, New York, NY 10021
www.frick.org
Michaelyn Mitchell, *Editor in Chief*
Hilary Becker, *Associate Editor*

In association with D Giles Limited,
4 Crescent Stables, London SW15 2TN

Copyedited and proofread by Miranda Harrison
Designed by Alfonso Iacurci
Printed and bound in Slovenia

Front cover: Plate, Rouen, ca. 1725 (cat. 34)
Back cover: Platter, Nevers, ca. 1660–70 (cat. 16)
Frontispiece: Platter, Rouen, 1738 (cat. 43)
At right: Gourd, Nevers, ca. 1640 (cat. 9)
Page 6: Plate, Nevers, ca. 1680–85 (cat. 21)
Page 8: Tazza, Rouen, ca. 1730 (cat. 39)
Page 12: Plate, Nevers, ca. 1680–90 (cat. 22)
Page 52: Dish, Lyon, ca. 1582–1600 (cat. 3)
Page 66: Basin, Moustiers, ca. 1760 (cat. 60)

Photos: figs. 1, 2, 7 © Victoria and Albert Museum; fig. 4 © The Trustees of The British Museum; cats. 1, 5–8, 12, 14, 15, 18, 20, 24–26, 28, 30–32, 35, 38, 42, 44, 46–50, 52, 53, 55–57, 59, 62, 64–66, 68–75 Christophe Perlès; cats. 4, 9, 10, 54, 61 Beylard, Ferrier & Lewandowski; cat. 19 Camille Leprince; cat. 27 Christie's. All other cats. Michael Bodycomb

Library of Congress Cataloging-in-Publication Data
Names: Vignon, Charlotte, author. | Knafel, Sidney R., writer of supplementary textual content. | Frick Collection, issuing body, host institution.
Title: Masterpieces of French faience : selections from the Sidney R. Knafel collection / Charlotte Vignon ; with Sidney R. Knafel.
Description: New York : The Frick Collection ; London : In association with D Giles Limited, [2018] | Published in conjunction with Masterpieces of French Faience: Selections from the Sidney R Knafel Collection on view at The Frick Collection from October 9, 2018. | Includes bibliographical references and index.
Identifiers: LCCN 2018000151| ISBN 9781911282310 (hardcover) | ISBN 9780912114736 (softcover)
Subjects: LCSH: Knafel, Sidney R.--Art collections--Exhibitions. | Faience--France--Exhibitions. | Faience--Private collections--Exhibitions.
Classification: LCC NK4305 .V54 2018 | DDC 738.3/7--dc23 LC record available at https://lccn.loc.gov/2018000151

CONTENTS

DIRECTOR'S FOREWORD

It all started about fifty years ago with a broken platter at a Parisian flea market. It was then that Sid Knafel first caught the collecting bug. In the intervening years, he has amassed one of the most important private collections of French faience in the world and become highly respected in this field. We are immensely grateful to Sid and his wife Londa for being such generous friends and benefactors of the Frick, and especially to Sid for allowing us to present so many pieces—all of them a promised gift to the Frick—from his exceptional collection. The Frick's ceramics holdings have grown in importance in recent years, especially in porcelain, so we are particularly pleased to display such a marvelous representation of the great variety and creativity of French faience.

We owe a great debt of gratitude to Decorative Arts Curator Charlotte Vignon for the customary rigor of her scholarship, as well as to Xavier F. Salomon, Peter Jay Sharp Chief Curator, for supporting this project with great enthusiasm. At the Frick, thanks are also due to Adrian Anderson, Michael Bodycomb, Rika Burnham, Tia Chapman, Julia Day, Diane Farynyk, Allison Galea, Lisa Goble, Joseph Godla, Caitlin Henningsen, Patrick King, Rachel Himes, Adrienne Lei, Genevra LeVoci, Alexis Light, Alison Lonshein, Jenna Nugent, Gianna Puzzo, Geoffrey Ripert, Heidi Rosenau, Joe Shatoff, Don Swanson, and Sean Troxell. The Frick's Editor in Chief, Michaelyn Mitchell, oversaw the production of the catalogue and, with Associate Editor Hilary Becker and editorial volunteer Serena Rattazzi, edited the text. We are indebted to Stephen Saitas, exhibition designer, and Anita Jorgensen, lighting designer, for their beautiful presentation of the exhibition.

We very much appreciate the major support for the exhibition generously provided by Melinda and Paul Sullivan and The Selz Foundation as well as the additional funding from Helen-Mae and Seymour R. Askin, Barbara G. Fleischman, Anne K. Groves, Mr. and Mrs. Michael J. Horvitz, Nancy A. Marks, Peter and Sofia Blanchard, Margot and Jerry Bogert, Jane Condon and Kenneth G. Bartels, Mr. and Mrs. Jean-Marie Eveillard, Barbara and Thomas C. Israel, and Monika McLennan.

Ian Wardropper
Director, The Frick Collection

ACKNOWLEDGMENTS

I join Ian in acknowledging our colleagues whose work ensured the high quality of this publication and the exhibition it accompanies, both of which aim to introduce French faience to museumgoers in this country. I wish to emphasize especially the tireless work of Michaelyn Mitchell, Editor in Chief, in overseeing the production of this beautiful publication, and the expertise of Patrick King, Head of Art Preparation and Installation, in the installation of the exhibition. My deep appreciation also goes to Curatorial Assistant Geoffrey Ripert for his support on all aspects of the project, as well as to Associate Conservator Julia Day for helping me better understand the technical aspects of French faience. I extend particular thanks to Camille Leprince for sharing with me his extensive knowledge of this subject. Our conversations in Oxford, Paris, and New York helped me to better appreciate the remarkable quality of Sid's collection.

Finally, I would like personally to thank Sid himself. Meeting him opened the door to an aspect of decorative arts that was new to me, one with which I quickly fell in love. Sid has been extremely kind, patient, and supportive and an ideal collaborator. I give my heartfelt thanks to him for all he does and has done for this project and for the Frick.

Charlotte Vignon
Curator of Decorative Arts, The Frick Collection

A COLLECTOR'S RECOLLECTIONS

Sidney R. Knafel

I never set out to be a collector. My late wife Susie introduced me to French faience through a Parisian flea-market purchase of a modest, repaired Rouen platter with a well-known pattern. Its visual and tactile appeal captured my curiosity, and I was possessed with a new thirst that required research to quench. The research generated frustrations. All books on the subject, other than a brief but exemplary volume by Arthur Lane, were in French—a stone wall for one dependent upon a schoolboy's long dormant French lessons. Museum exposure was limited in the United States to a restrained display at the Metropolitan Museum of Art, secreted in a dim lower-level gallery and seldom changed. French museums and dealers were an illusory balm, distanced by time and financial limitations. The thirst persisted as my research erratically advanced. An English edition of a superb overview by Jeanne Giacometti was then published, and eventually more money and vacation time made travel and occasional acquisitions feasible. In sum, there was sufficient success to reward my efforts and patience and to encourage my pursuit of knowledge and acquisitions. Consequently, I learned the challenges and delights of being a collector. This took nearly half of the fifty-five years that have passed since Susie handed that Rouen platter to me.

Over time, I discovered my own territory for diversion, as well as for concentrated focus. At will, I could find intellectual refreshment, accompanied by some humility and occasional starch for the ego. Only in retrospect have I understood the particular allure French faience has had for me. It was nearly two decades ago that I realized not only that my collection had become almost exclusively French but also that it was for the most part devoted to faience that is *grand feu* (high fired) rather than *petit feu* (low fired). Indeed, this collection had been determined by my heart, but it

became fully gratifying as my mind worked to organize the approximately 250 pieces I have accumulated.

Though the collection was inspired and initiated by Susie, it has been my second wife, Londa Weisman, who has adjusted the display, reinforced my judgment, and advocated still more purchases, even when wall space became scarce. She has introduced a most welcome new dimension.

I also want to acknowledge other influences. All of the French dealers, from small town shopkeepers to major authorities in Paris, were patient and generous with a young new client. More focused support came over the last three decades. Christophe Perles has been a vital participant with a discriminating eye, consistently mentoring me to an ever higher standard of quality and beauty. Louis Lefebvre provided the unique, the unknown, and many of the most exciting elements of my faience. Camille Leprince, young and scholarly, has expanded the foundation of my collection in recent years with a wondrous group of very early Lyon and Nevers treasures.

My thoughts about this exhibition cannot be concluded without thanking The Frick Collection for encouraging and then providing precious gallery space and time for all that is displayed. Director Ian Wardropper has nurtured such an exhibition for some years, as the collection has matured. The creative and persistent organizer of this presentation, Charlotte Vignon, Curator of Decorative Arts, brought the project to fruition.

Why expose these objects to the world? The enormous happiness I have enjoyed throughout the process of collecting them has inspired me to entice others, especially Americans, to know French faience and to pursue the countless objects worthy of acquisition and adoration.

INNOVATIVE TRADITION
Two Centuries of French Faience in the Knafel Collection

Charlotte Vignon

> [Ceramics] fulfill us, giving us the tiles for roofs, the bricks for walls, the receptacles for wine, the tubes for water, and all of those objects which one makes on the wheel and forms with one's hands.
>
> —PLINY THE ELDER, AD 77–79

Used all over the world since clay was first crudely fashioned to make functional containers, ceramics encompass a multitude of forms and functions, from utilitarian objects to architectural elements to religious pieces employed during sacred ceremonies or gifted to the gods. The word *ceramic* derives from the Greek *keramos*, meaning "argil" (clay), and is used to describe any object made from fired clay. In order to create ceramics, one must have each of the four elements: earth, fire, water, and air.[1]

EARTH AND FIRE

The earth element of ceramics is clay, a raw material found almost everywhere and in infinite variety. Composed primarily of aluminum silicates and other minerals, clay is formed from the decomposition of igneous rocks such as granite and basalt. All clays are plastic when wet and hard once dried or fired. Their colors generally vary from white to gray, or yellow to red, depending on their origin and mineral composition. Such factors also influence the firing temperature required.

In the West, ceramics fall into three main categories: stoneware, porcelain, and earthenware. Stoneware is made of pale clays—often buff or gray—that when fired at a high temperature (above 1200 °C) become dense and practically impermeable but only

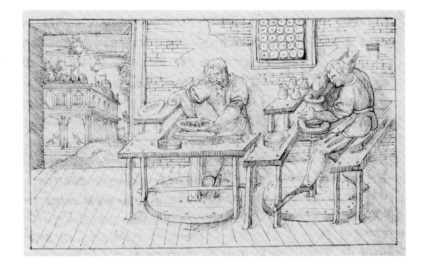

partially vitrify. Porcelain is typically made with clay that contains kaolin, feldspar, and quartz. When fired at a very high temperature (up to 1400 °C), it becomes white, translucent, and fully vitrified—an impermeable material with a glasslike appearance. Earthenware, the vast third category comprising any ceramic that remains porous when fired at temperatures under 1100 °C, includes French faience, the subject of this book.

WATER AND AIR

Dishes, plates, vases, and bowls are generally shaped by throwing wet clay on a potter's wheel powered by the artisan's feet, as seen in *The Three Books of the Potter's Art*, written in about 1557 by Cipriano Piccolpasso (fig. 1).[2] Molds are preferred for complex shapes like ewers or dishes with high-relief borders, as well as for flat objects such as plates and dishes that need to be duplicated or produced in series. Spouts and handles are often shaped by hand (and sometimes using molds). With these three main techniques, almost

any shape can be created. If an object is made of several pieces, they are attached together with "slip"—a mixture of clay and water. After being shaped, a piece is left to dry and then fired at about 1000 °C.

Because faience—like other types of earthenware—remains porous after firing, it must be covered with a glaze. Composed of silica (sand) and an oxide containing sodium, potassium, or lead, this transparent glaze renders the object impervious to liquids. The glazes used for faience include a tin oxide employed to create an opaque white surface that covers the less attractive color of the underlying clay and creates a stable surface for painting. Other tin-glazed earthenware produced in Europe includes Hispano-Moresque ware made in Spain, Italian Renaissance maiolica, and delftware.

French faience is typically categorized according to whether it is decorated using the *grand feu* (high fired) or *petit feu* (low fired) technique. With the *grand feu* technique, metal oxides are mixed with water and applied onto the tin-glazed surface before firing at a temperature of about 900 °C (1650 °F). The palette is necessarily limited to those oxides that can withstand such heat: cobalt (blue), antimony (yellow), manganese (purple and brown), iron (red-orange), and copper (green). These oxides are absorbed into the unfired glazed surface and permanently fused into the tin-glazed layer upon heating in a kiln. The Knafel Collection includes pieces made with the *grand feu* technique exclusively. With the vogue for porcelain at its height during the mid-eighteenth century, however, came the desire to expand faience's limited range of colors. This led French

potters to develop the *petit feu* technique, which allows for a more varied palette. The painter begins with colors that can tolerate higher temperatures and finishes with those that require lower temperatures, such as pink and gold (which cannot be fired above 750 °C). Each technique results in a distinct aesthetic.

In both the *grand feu* and *petit feu* techniques, the painter employs freehand drawing for simple motifs and uses "pouncing" for more complex designs, such as religious and mythological scenes after engravings (fig. 2). Pouncing involves drawing a design on a tracing sheet and puncturing small holes into the outline. The tracing sheet is then placed onto the object to be decorated, and the sheet is rubbed with a dark powder (such as charcoal) and then lifted off. The design emerges through the perforated holes and helps the painter position the various oxides. Once applied, the oxides cannot easily be removed or retouched, so there is little margin for error. Moreover, the painter must also be able to anticipate the color transformation of the oxides, which change from gray or brown into vivid colors after firing. Traditionally, oxides were processed in the potter's workshop, so they vary in intensity from one workshop to the next.

ORIGINS

The technique for making tin-glazed earthenware was something of a "potter's secret," a recipe passed down over the centuries by migrant potters and artisans. It was first discovered in about 800 AD, in what is modern-day Iraq, by Islamic potters who were probably attempting to imitate the Chinese porcelain that had recently been imported to the Middle East.[3] In subsequent centuries, Islamic potters created a sophisticated pottery

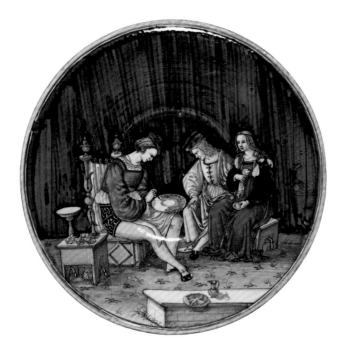

Fig. 2. Plate *(A Maiolica Painter and Two Clients)*. Attributed to Maestro Jacopo, Cafaggiolo, ca. 1510–15. Diam. 9½ in. (23.9 cm). Victoria and Albert Museum, London (1717-1855)

renowned for its luster decoration (made with copper and silver oxides) reminiscent of metal, especially gold. With the westward expansion of Arab culture and continuing trade in the Mediterranean, this technique reached southern Spain, in particular, the port city of Malaga (Andalucia). During the fourteenth and fifteenth centuries, Spanish potters near Valencia developed splendid Hispano-Moresque lusterware that was admired all over Europe.

First introduced in Italy during the thirteenth century, tin-glazed earthenware experienced a Golden Age during the fifteenth and sixteenth centuries with production at manufactories in Urbino, Casteldurante, Pesaro, Faenza, Deruta, and Gubbio. The word *maiolica* had been used in Italy during the fourteenth century to describe

the Hispano-Moresque lusterware imported from Spain and was later applied to the same pottery produced by Italian potters. The word comes from the Spanish island of Majorca in the Mediterranean, known by Italians until the fourteenth century as Isola di Majolica. It was then believed to be a center of production for Hispano-Moresque luster-ware, although it was never more than a marketplace for such pottery. Italians may also have misunderstood the Spanish term for lusterware, *obra de Malica* (ware from Malaga), and transformed it into maiolica since Majorca was more familiar to them than Malaga.[4]

By the sixteenth century, the term *maiolica* was used, as it is today, to describe any tin-glazed earthenware—whether painted or lustered—produced in Italy during the Renaissance.[5] Italian Renaissance maiolica elevated tin-glazed earthenware from a sophisticated type of pottery to an ambitious art form that rivaled contemporary silver and ancient ceramics and also strongly influenced the production of tin-glazed pottery in France. This influence is reflected in the French word *faience*, which derives from the northern Italian city of Faenza, an important center of maiolica production during the Renaissance.

LYON ✱ FRENCH FAIENCE MADE BY ITALIAN MAIOLICA POTTERS AND PAINTERS

Whether drawn by the economic prosperity of a particular town, or the patronage of a prince, or fleeing from religious or political persecution, artists and craftsmen were often itinerant, traveling between cities, from royal to princely courts, and in and out of their own countries. The production of tin-glazed earthenware in France is directly

Fig. 3. Map of present-day France showing the geographical location of faience manu-factories in Rouen, Nevers, Moulins, Lyon, Moustiers, Montpellier, and Marseille

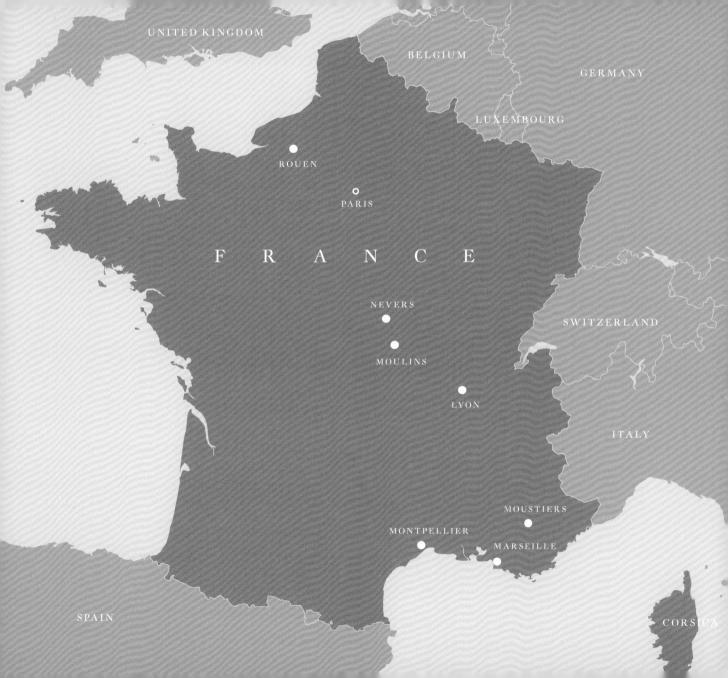

related to the arrival in Lyon, during the second half of the sixteenth century, of several Italian maiolica potters and painters who were seeking opportunities outside Italy.[6] Lyon was then a culturally rich city at the crossroads of Italy, France, and the Holy Roman Empire (fig. 3), with a large Italian community, documented since 1512.[7]

One of the Italian artisans in Lyon was Sebastiano Griffo, a potter from Genoa who, in 1556, received a tax exemption for establishing a *manufacture de terre* (manufactory of clay), "a novelty in the city and in the kingdom of France."[8] Griffo's manufactory may have been taken over by another Italian, Giovanfrancesco de Pezaro (or Pesaro, from the Italian city of Pesaro), who claimed to have brought with him—along with his brother Cristoforo—the techniques of Italian maiolica. For several years, the two brothers (known in French as Jean-François and Christophe Pézard) enjoyed a monopoly over the production of Italian-style maiolica in Lyon. They employed a number of Italian potters who were either from or had worked in the northern Italian region of Liguria, at Albissola or at Savona, near Genoa. In the early 1570s, they were joined by Domenico Tardessir (from Faenza) and the brothers Seiton (or Saitone or Suettone), as well as the maiolica painter Giulio Gambini (Jules Gambin). In 1581, the Urbino painter Gironimo Tomasi (also known as Gironimo di Tomaso and in French as Jérôme Thomas) moved to Lyon. Also in the early 1580s, Agostino di Domenico Conrado (or Corrado; in French, Conrade) established a workshop in Lyon with fellow Italian potter Bernardo di Giulian Salomone. They produced tin-glazed earthenware and also imported, from Savona, Italian maiolica decorated with polychrome grotesques and colorful narrative scenes called *istoriato*.[9]

Other Italians are known to have worked in Lyon, but their work has not yet been identified. The only recorded objects with signatures are those painted by Gironimo

Tomasi (produced throughout a career spent in Urbino and Albissola, as well as Lyon (fig. 4).[10] Stylistic comparison allows for possible identification of a group of examples in the Knafel Collection as being made by Tomasi in Lyon, some time between his arrival in the city in 1581 and his death in 1602 (fig. 5 and cats. 1, 3, 4).[11] This rare group of early French faience pieces of very high quality is painted in the tradition of Italian maiolica produced in the second half of the sixteenth century, in the Fontana workshop in Urbino, where Tomasi received his early training.[12] Urbino wares were celebrated for their colorful *istoriati* and grotesques, combining sphinx-like creatures, winged figures small and large, horses, and fantastic birds, all painted on a white ground. Because such maiolica continued to be produced in Urbino by the Patanazzi family, who took over the Fontana workshop until about 1620,[13] and because so little is known about the production of the Italian potters working in Lyon, experts continue to debate the dates and attribution of such pieces. Some claim Italian origins and others French ones (cats. 1, 6).[14]

In the early 1590s, Lyon lost its political and economic independence, and this adversely affected the growth of manufactories and workshops, including those making faience. Fear of plague and famine further prompted the city's Italian potters to move to Nevers, in central France. The city had been ruled by an Italian prince, Luigi Gonzaga of Mantua, since his marriage in 1565 to Henriette of Cleves, heiress of the city.

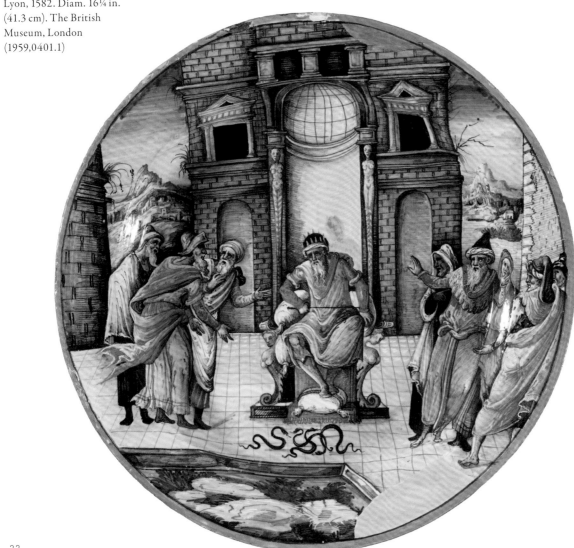

Fig. 4. Dish (*Aaron's Rod Changed into Serpents*). Painted by Gironimo Tomasi, Lyon, 1582. Diam. 16¼ in. (41.3 cm). The British Museum, London (1959,0401.1)

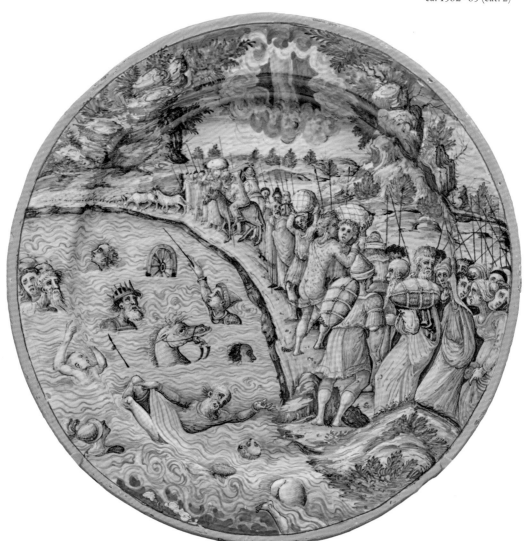

Fig. 5. Plate (*The Crossing of the Red Sea*). Painting attributed to Gironimo Tomasi, Lyon, ca. 1582–85 (cat. 2)

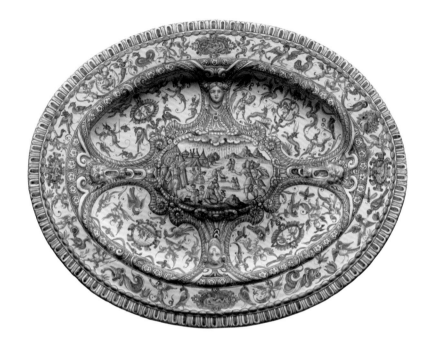

Fig. 6. Dish (*The Gathering of Manna).* Attributed to the workshop of Antoine Conrade, Nevers, ca. 1630–50 (cat. 8)

NEVERS ✱ THE BIRTH AND GOLDEN AGE OF FRENCH FAIENCE

Among the numerous Italian artists and craftsmen, including potters and Venetian glassmakers, whom Luigi Gonzaga attracted to Nevers was Augustin Conrade (Agostino di Domenico Conrado, mentioned above) from Albissola in Liguria. After spending a few years in Lyon, he established a workshop in Nevers in 1584, where he was soon joined by his nephews Dominique, Baptiste, and Bernardin. In 1589, the maiolica painter Giulio Gambini (Jules Gambin) joined him from Lyon.[15] Unfortunately, the sixteenth-century production of Italian potters in Nevers is

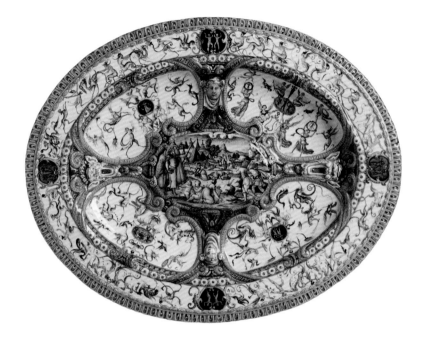

known only through a few pieces.[16] Some signed and dated pieces have led to much better knowledge of the production of the following century, although questions of attribution and dating remain for the years around 1600.

With the patronage of Parisian and provincial nobility and bourgeoisie, Nevers expanded rapidly, becoming the main center of faience production in France.[17] Several manufactories opened under the names of Les Trois Rois (The Three Kings) and La Croix d'Or (The Golden Cross), founded in 1608 by Dominique Conrade and in 1610 by Baptiste Conrade, respectively. Antoine Conrade, great nephew of Augustin Conrade,

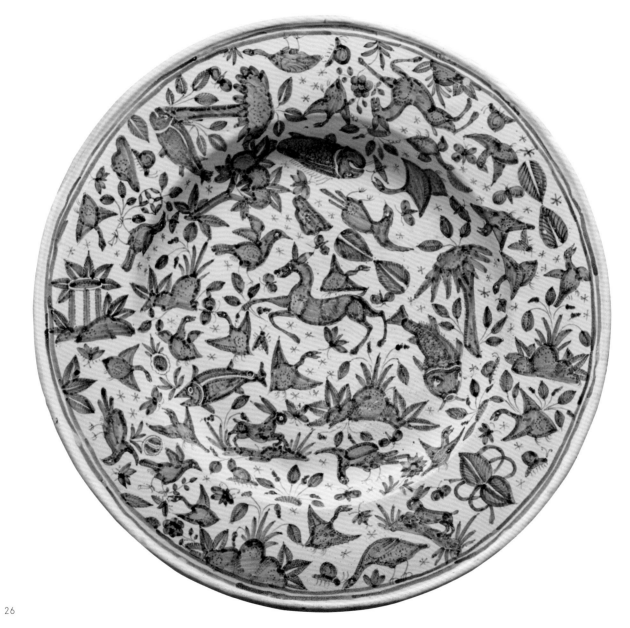

was the head of Les Trois Mores (The Three Moors)—the largest workshop in Nevers at the time—from 1626 until his death in 1647. Among others that opened were the Autruche (Ostrich), founded by Pierre Blanchet in 1619, and Ecce Homo, directed by Nicolas Estienne in 1640.[18]

To satisfy a clientele passionate about Italian art, the faience workshops of Nevers produced Italian-style maiolica with *istoriato* and grotesque decoration until the middle of the seventeenth century, leading to much confusion today as to the attribution and dating of such pieces.[19] The Knafel Collection is notable for its rich holdings of faience made in Nevers from about 1600 to 1650. These works demonstrate the lasting influence of Italian models on the Nevers production, as well as the popularity in France of ceramics made in Italy seventy years earlier.[20] Not only did *istoriato* and grotesque decoration originate in Italy, but the complex forms of faience sometimes followed Italian models. Such is the case with a spectacular plate probably made in the workshop of Antoine Conrade, after similar pieces produced in the Fontana workshop in Urbino about 1560–80 (figs. 6, 7).[21] Like most of the pieces made in Nevers in the early seventeenth century, this dish was until recently considered to be a great example of Italian Renaissance maiolica. However, its monochrome blue decoration was mainly produced in Nevers—after examples made in Savona, Liguria—and never in Urbino.

Another particularity of the Nevers craftsmen was to paint an Italianate *istoriato* in the style of Urbino onto shapes and forms not used by Italian potters, as on a pair of covered jars after a traditional Chinese form (cat. 12).[22] Over time, the typical Italian *istoriato* evolved at Nevers into a style that was more French, characterized by a paler palette (cats. 10, 11).[23] With a growing number of talented French painters, inscriptions on the

Fig. 8. Plate. Workshop of Antoine Conrade, Nevers, ca. 1645 (cat. 13)

back of faience pieces were increasingly written in French, such as "Persee Et Meduse, 1635" (Perseus and Medusa, 1635), found on a plate attributed to the French painter Denis Lefebvre (cat. 7),[24] and "de conradi A Nevers" (by Conradi at Nevers), inscribed on the back of a plate from Conrade's workshop (cat. 14).[25]

Monochrome blue was first developed in Savona (in the region of Liguria) and brought to France by Italian immigrant potters, but it became a Nevers specialty. Several pieces in the Knafel Collection are influenced by the blue-and-white production of Savona, some depicting rural landscapes, occasionally after chinoiserie scenes showing an imagined East Asia. Small figures dressed in Chinese costumes are set in Asian-style landscapes (cats. 14, 15).[26] A rare example of this type is a large plate with blue fish, birds, and other animals painted on the surface of the piece, so as to cover as much white ground as possible without overlap (fig. 8). This follows a decorative style imported from Persia.

By the middle of the seventeenth century, Nevers potters and painters were exploring new types of decoration, probably in the hope of forging a new artistic

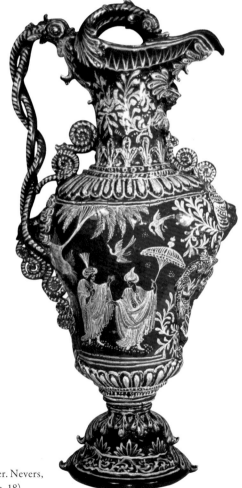

Fig. 9. Ewer. Nevers, ca. 1680 (cat. 18)

identity and attracting a broader clientele, while also responding to the artistic revolution taking place in France under Louis XIV (r. 1643–1715). Italian potters had by this time been established in France for several generations, and some French potters had no Italian roots at all, so the Italian influence became weaker. At the forefront of the new production of faience was the use of a dark blue background, often referred to as "Nevers blue," represented in the Knafel Collection by a very large ewer that is one of the most ambitious known examples of French faience (fig. 9), along with a recently discovered basin (fig. 10).[27] Both pieces are decorated with oriental figures wearing turbans and peasant women and peddlers, surrounded by trees, birds, and luxuriant vegetation, painted in white. Nevers blue can also be seen in the Knafel Collection on a

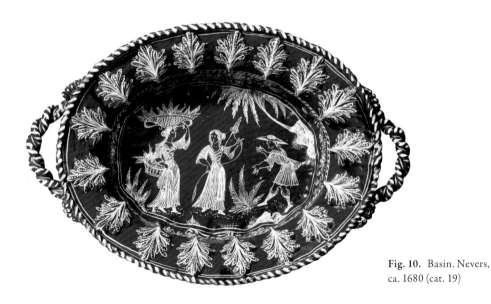

Fig. 10. Basin. Nevers, ca. 1680 (cat. 19)

large beautiful oval platter painted in white, yellow, and ochre with birds and bouquets of tulips, roses, daisies, and carnations, reminiscent of the Iznik tiles made in western Anatolia during the sixteenth century (cat. 16 and back cover).[28]

Over the years, Nevers potters and painters refined the technique of tin-glazed earthenware, which enabled them to produce larger and more ambitious pieces, and also developed new colors and a wide range of decorative styles. For example, they invented an emerald green that was used to decorate both borders and entire pieces. Their love of vibrant colors came together in a type of decoration called *à la palette de Nevers* (in the palette of Nevers), which is characterized by the use of *grand feu* colors—deep blue, dark manganese purple, bright yellow, orange ocher, and olive green—applied next to each other on large surfaces, as, for example, on a rare orange-tree planter, decorated with Asian-style landscapes (fig. 11).[29] These pieces, as well as others in the Knafel Collection made between 1680 and 1685 (cats. 18–27), represent the apogee of Nevers production.[30]

ROUEN ✱ THE CAPITAL OF FRENCH FAIENCE

During the sixteenth century, the city of Rouen in Normandy was celebrated for Masséot Abaquesne's faience workshop. From about 1526 until his death in 1564, it produced, almost exclusively, pharmacy jars and floor tiles for French castles.[31] After Abaquesne's death, however, his son was unable to sustain the workshop's activity beyond the beginning of the seventeenth century. Eighty years later, Rouen once again became an active center of faience production when, in 1644, Nicolas Poiret received a royal privilege that

Fig. 11. Orange-Tree Planter. Nevers, ca. 1680 (cat. 20)

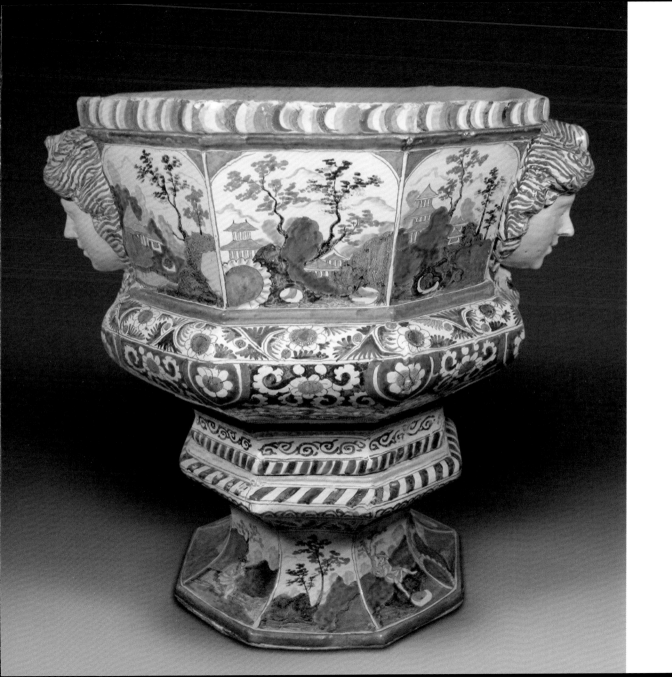

32

gave him the exclusive right to produce, for fifty years, "in the province of Normandy all kinds of vessels made of white faience and covered with a colorful enamel [glaze]."[32] Edme Poterat directed Poiret's manufactory until 1674, when he acquired it. With such an advantageous commercial monopoly, plus the help of a few fellow *faïenciers* (makers of faience) from Nevers and potters from Delft (a city in the Netherlands that started producing tin-glazed pottery in about 1620),[33] Poterat and his two sons, Michel and Louis, dominated the production of faience in Rouen until the late seventeenth century, transforming the city into a major center of faience production in Europe.[34]

When the Poterat family's monopoly expired in 1698, several faience manufactories opened in Rouen. The first half of the eighteenth century saw the establishment of eighteen new manufactories, with fourteen operating simultaneously during that period. Although eighteen manufactories were still active in 1781, the production of faience in Rouen started to decline in the 1790s, and by 1802 there were only seven manufactories. The last of them closed in 1851.[35]

L'Art de la fayence (*The Art of Fayence*), written between 1735 and 1747 by the local scholar Pierre Paul Caussy, explains in great detail the organization of an eighteenth-century faience manufactory in Rouen. Directed by a "master"—who was rarely a potter—the average manufactory employed about twenty workers, including several painters, *tourneurs* (those who created faience pieces on a potter's wheel; from the French verb *tourner*, meaning "to turn"), molders, journeymen, and apprentices. The painters and *tourneurs* received four years of training, after which they were granted the title *faïencier*.[36]

The production of faience in Rouen was initially influenced by the fashionable monochrome blue decoration developed in Nevers and Delft, depicting pastoral or

Fig. 12. Platter. Rouen, ca. 1725
(cat. 33)

33

chinoiserie scenes.[37] This was a direct response to the European craze for Chinese blue-and-white porcelain, which began in the sixteenth century with the first major imports of objects to Portugal and was amplified by the trade between the Netherlands and Asia through the East India Company (founded in 1602). This type of decoration can be seen in the central scene of a large platter in the Knafel Collection (cat. 31).[38] It is surrounded by two decorative borders imitating embroidery, called lambrequins. This new type of decoration, which became the signature of Rouen faience until the mid-eighteenth century, also derives from Chinese porcelain and was later adopted by Dutch and Nevers potters.[39] The tradition stems from the habit of late sixteenth- and seventeenth-century Chinese potters of placing a piece of embroidery around the neck of porcelain vases. Later, Chinese potters decorated export porcelain with motifs inspired by such pieces of embroidery, before Dutch, Nevers, and Rouen potters started to do the same.[40] It was in Rouen that this highly decorative ornament gained distinction.

Pieces in the Knafel Collection demonstrate the varied ways in which the lambrequin motif was used in Rouen—sometimes covering an entire piece (cats. 29, 30, 35) and other times used in simple or multiple borders, thick or thin, surrounding a painted scene, small figures of children, bouquets of flowers, or coats of arms (fig. 12 and cats. 28, 29, 31, 32). It appears in monochrome blue (cat. 35), blue and red (a difficult color to produce at the time)[41] (cats. 28–30), or polychrome (cats. 32, 33).[42] Lambrequins are often combined with *ocre niellé* (inlaid ochre), the rarest and most prestigious type of decoration developed in Rouen (fig. 12 and cats. 32–35). Blue foliage is painted on an ochre ground to create a decorative effect that simulates the silversmith's technique of *niellage* (niello), a process in which black enamel is inlaid on precious metal.[43]

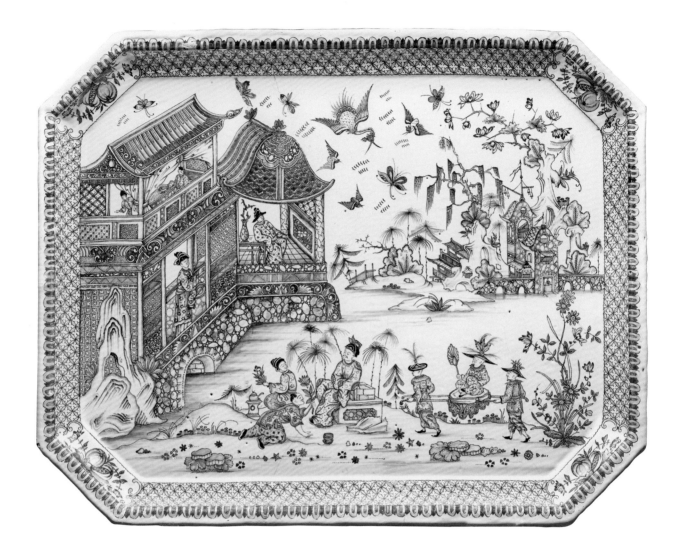

Fig. 13. Tray. Rouen,
ca. 1730–40 (cat. 40)

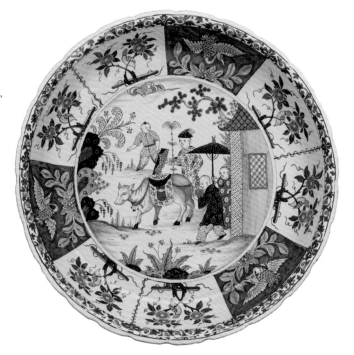

Fig. 14. Dish. Rouen, ca. 1730–40 (cat. 41)

Alongside this highly decorative production, Rouen potters continued to respond to Europe's passion for Asia by producing pieces with Chinese motifs (pagodas, male and female Chinese figures, children, exotic fauna and flora, Asian-style landscapes). These motifs were not painted in blue and white, as they had been earlier, but in polychrome—inspired by colorful Chinese porcelains (fig. 13 and cats. 39, 43), as well as by Japanese Imari ware, characterized by extensive floral motifs painted in radiant blue and iron-red (fig. 14).[44]

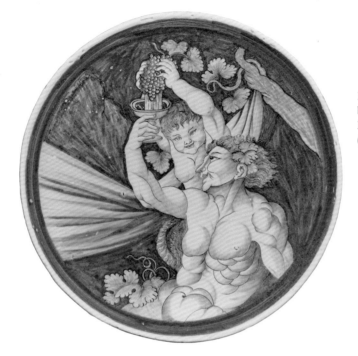

Fig. 15. Dish. Painted by Pierre II Chapelle, Rouen, ca. 1725–30 (cat. 37)

The quality of the painting and the varied types of decoration that developed in Rouen during the first half of the eighteenth century are further exemplified in the Knafel Collection by two rare pieces that rival paintings on canvas: a dish featuring Bacchus as an allegory of autumn, by Pierre II Chapelle (fig. 15),[45] and a tray featuring a peasant scene in the manner of the seventeenth-century Flemish painter, David Teniers the Younger (fig. 16).

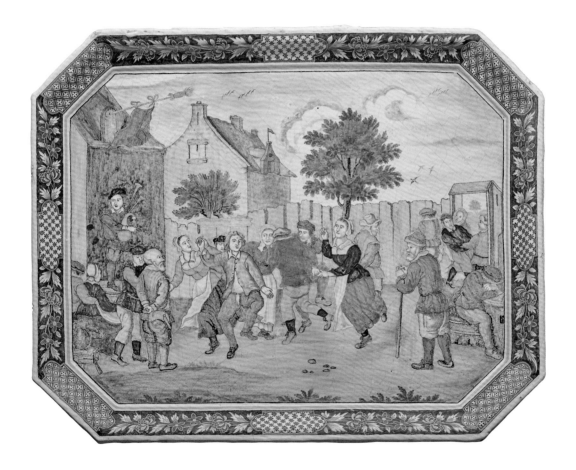

Fig. 16. Tray. Rouen,
ca. 1740–50 (cat. 45)

MARSEILLE AND MOUSTIERS ✳ THE EXPANSION OF FRENCH FAIENCE TO THE SOUTH OF FRANCE

Intended to help fund France's ongoing and expensive wars, the sumptuary laws passed by Louis XIV in 1679, 1689, and 1709 contributed to the rapid geographic expansion and stylistic development of French faience. In December 1689, the Sun King sent his own collection of luxurious silver furniture to the royal mint, an example reluctantly followed by the aristocracy, who were pressured to melt down their own objects in precious metals—mostly silver table services and decorative ware. As described by the Duke of Saint-Simon, this resulted in a new frenzy among French aristocrats for domestic faience: "In eight days, all who were of grand or considerable standing used only faience services. They emptied the shops selling it, and ignited a heated frenzy for this merchandise, whereas the mediocre [the resisting aristocrats] continued to make use of their silver."[46]

In the late seventeenth century, the region of Provence in southeastern France emerged as a new, important center of faience production, with workshops opening at Moustiers and in the port city of Marseille at about the same time. About 1679, Pierre Clérissy opened the first manufactory of faience at Moustiers.[47] It was operated by the same family for three generations, until 1783. Pierre's brother, Joseph Clérissy, opened the first faience manufactory in Saint-Jean-du-Désert, near Marseille.

In Moustiers, several manufactories that opened during the first half of the eighteenth century presented strong competition for the Clérissy family, especially with the arrival of Joseph Olérys, a talented potter from Marseille. Olérys worked in his hometown for three years from 1723, before being recruited by the Count of Aranda to direct the count's newly founded faience manufactory in the Spanish town of Alcora, near

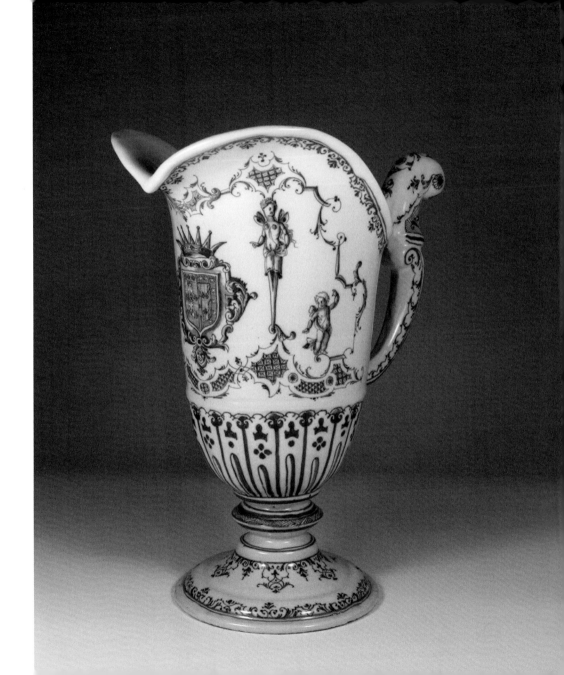

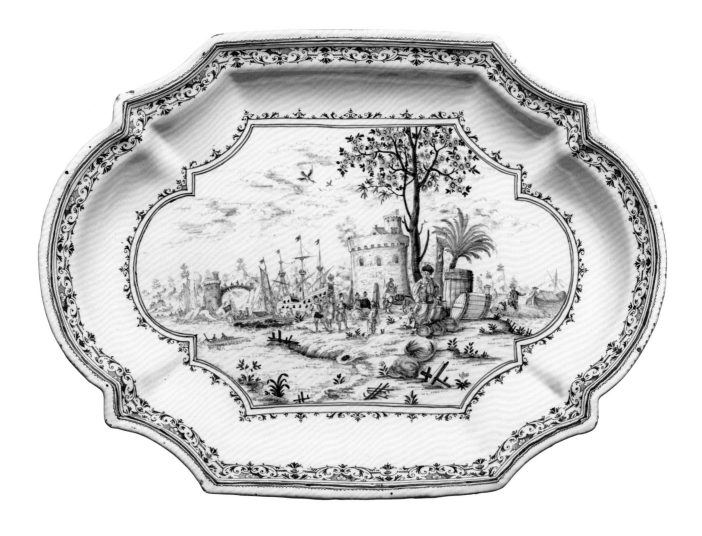

Fig. 17. Ewer. Clérissy manufactory, Moustiers, ca. 1700–25 (cat. 50)

Fig. 18. Platter. Clérissy manufactory, Moustiers, ca. 1730–40 (cat. 51)

Valencia. In 1738, Olérys opened his own manufactory at Moustiers with his brother-in-law, Jean-Baptiste Laugier (whence the mark *L* covered by an *O* found on pieces from the manufactory). In about 1748, two of their employees, Joseph Fouque and Jean-François Pelloquin, opened their own manufactory: Fouque & Pelloquin. In 1783, Fouque purchased the old Clérissy family business, which continued its activities until the manufactory closed permanently, more than half a century later, in 1849. Jean-Gaspard Féraud and Joseph-Henri Berbegier opened a factory in 1779, and several other relatives of Féraud were also *faïenciers*. Pierre-Toussaint Féraud, director of the last faience manufactory in Moustiers, closed his business in 1874.

Several monochrome blue pieces in the Knafel Collection—including a large plate virtuosically painted with a boar hunt surrounded by a lambrequin (cat. 49)—beautifully represent the Clérissy manufactory's creations.[48] The collection also includes a superb ewer in the form of a helmet (fig. 17), inspired by contemporaneous silverwork, painted with motifs that ultimately derive from the compositions of Jean Bérain, the talented designer of Louis XIV.[49] This new and ingenious style of decoration was introduced to French faience at the Clérissy manufactory and influenced faience manufactories throughout France.

The masterpiece of Moustiers faience in the Knafel Collection, however, is undoubtedly a large platter dating from 1730 to 1740, also from the Clérissy manufactory, that depicts a complex scene with Asian merchants in the foreground and soldiers in the background (fig. 18). Painted in monochrome blue with yellow highlights and touches of green, this highly accomplished piece marks the transition from blue-and-white to full polychrome decoration.[50] The Knafel Collection includes several fine examples of such early polychrome, which was first developed in the Clérissy manufactory and later

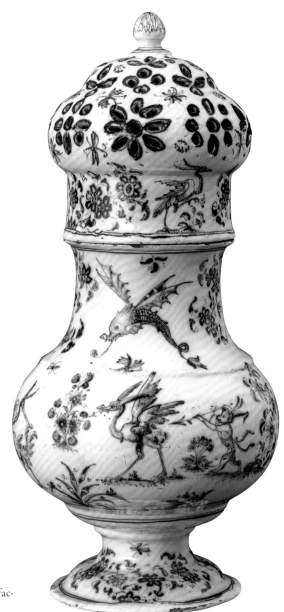

Fig. 19. Baluster-Shaped Sugar
Caster. Olérys and Laugier manufac-
tory, Moustiers, ca. 1750 (cat. 58)

by Olérys and Laugier (cats. 52, 53).[51] Joseph Olérys, however, is probably the inventor of the most celebrated type of decoration found on Moustiers faience, characterized by asymmetrical compositions of small and fanciful figures—grotesques—painted with a lightness of touch and yet great precision, in monochrome manganese or polychrome (fig. 19 and cats. 54, 56–59).[52]

The development of faience production at Marseille[53] is closely related to that of Moustiers. The two centers were only about eighty miles apart, and many *faïenciers* working at Marseille were from Moustiers. Two important manufactories launched the production of faience at Marseille. The first was founded in the late 1670s by Joseph Clérissy at Saint-Jean-du-Désert (just outside Marseille). The second was founded in 1710, north of the city, and was directed by Clérissy's granddaughter, Madeleine Héraud, together with her husband Louis Leroy. Joseph Clérissy's workshop benefitted immensely from the presence of two brothers, both painters on faience: Jean-Baptiste and François Viry. When Joseph Clérissy died in 1688, François Viry married his widow and for several years directed the manufactory before it was taken over by Joseph Clérissy's son, Antoine, who ran it from 1697 until 1733. Meanwhile, Madeleine Héraud's factory was directed by her son—bearing the same name as her husband—from about 1728 until 1750. In 1732, Joseph Fauchier, previously an associate of Madeleine Héraud, opened the third and most successful faience manufactory in Marseille during the first half of the eighteenth century.

The faience produced at Marseille was influenced by that developed at Moustiers, making the attribution of unmarked pieces quite challenging (cats. 61, 66).[54] But Marseille manufactories also developed their own styles. For example, the Leroy

Fig. 20. Platter. Leroy manufactory, Marseille, ca. 1720–30 (cat. 63)

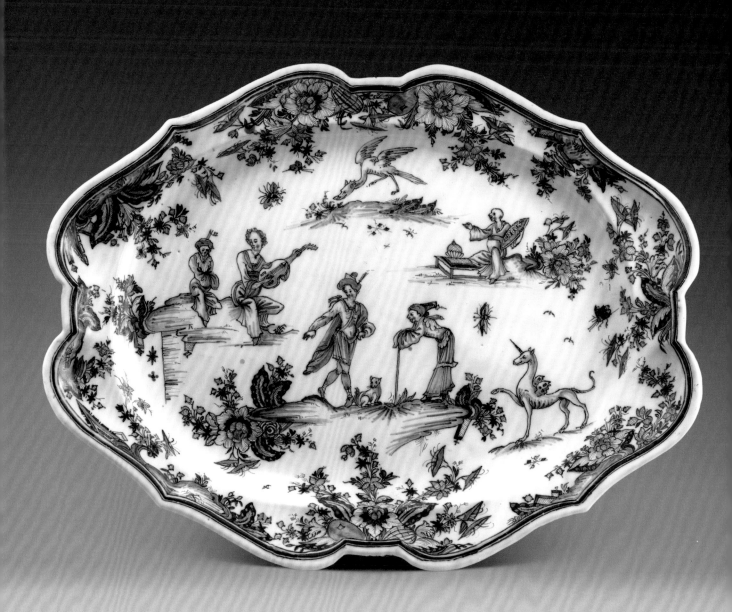

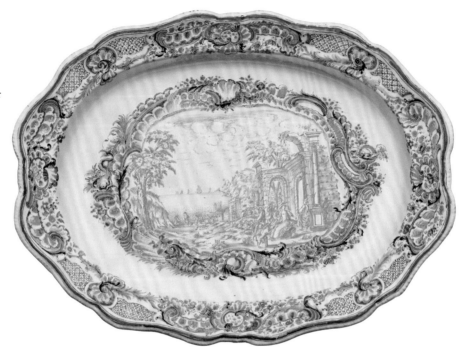

Fig. 21. Platter. Fauchier manufactory, Marseille, ca. 1730–40 (cat. 67)

manufactory created a kind of flower that looks like a starfish, always painted in red, as seen around the borders of a large platter in the Knafel Collection (fig. 20).[55] Likewise, the Fauchier manufactory is celebrated for its "Don Quixote" services with scenes from the famous Spanish novel by Cervantes painted in monochrome yellow (ochre), surrounded by rococo borders composed of asymmetric lines, shells, and latticework. A fine example of this type in the Knafel Collection features a depiction of an aristocratic couple and other characters near the ruins of an old castle or temple (fig. 21).[56]

MOULINS ✳ A SMALL BUT IMPORTANT CENTER OF PRODUCTION

During the eighteenth century, workshops established elsewhere in France expanded the production of faience and featured new types of decoration and forms that were characteristic of each region and manufactory. A new center emerged in 1727 in Moulins, near Nevers.[57] The pieces from Moulins in the Knafel Collection reflect the originality and high quality of faience made outside larger centers of production. Two plates in particular demonstrate the ambitions and virtuosity of painters at Moulins with their depiction of scenes and motifs originally painted by Alexis Peyrotte and later engraved by Gabriel Huquier (cats. 73, 74).[58] A puzzle jug—with its typical perforated neck here in the shape of flowers—was technically challenging to make as it was designed not to spill its content through the holes (cat. 75).[59]

FORM AND FUNCTION OF FRENCH FAIENCE

The value of a piece of French faience depended somewhat on its importance, its price, the nature of the commission, and the patron who first owned it. During the late sixteenth and seventeenth centuries, objects in faience were costly and were therefore acquired, collected, and gifted exclusively by patrons at the highest levels of French society. Consequently, the early pieces from Lyon and Nevers were originally intended for display on a credenza (a sideboard used to display valuable plates), to be admired by their owners and guests.[60]

The spread of faience workshops in Nevers, Rouen,[61] and elsewhere in France during the eighteenth century inevitably changed the status of these objects and hence their function. One of the most important changes was the use of faience to serve and eat

food. To ensure the success of their workshops, French potters—beginning in Rouen—closely followed the culinary developments occurring in France at the time.[62] Multiple dishes in different forms and sizes were created in response to the requirements of the *service à la française,* which necessitated serving the various components of a particular course at the same time. Each meal involved at least three courses, beginning with soup, followed by fish and roasts, then salad, and finally dessert. The use of faience was initially restricted to the end of a meal, primarily for dessert services, with metal still favored for main courses.[63] However, over the course of the century, the use of faience wares extended to the entire meal. Potters often copied silver designs for soup tureens, platters, sauceboats, salt-cellars, sugar casters, and mustard pots, as well as other vessels.

As the eighteenth century progressed, faience was increasingly used at all times of the day. In the morning, small faience boxes and jars stored pomades, powders, patches, and other make-up accessories, accompanying silver and porcelain on a dressing table for "la toilette." A covered bowl or cup in faience was often used to drink broth or a hot beverage while dressing, and objects like inkpots, snuffboxes, perfume bottles, and small teacups were often made in faience as well. In France, during this period, faience was also used to store medicinal plants and other pharmaceutical remedies, as had been done in Spain since the thirteenth century and in Italy since the fifteenth century. Apothecaries used jars of different shapes and sizes, some with long necks or spouts to store liquids, others with covers to protect powders. At home, medicines were kept in smaller jars and pots, which could also be made in faience.

*

The production of French faience spans more than two centuries—from its first introduction in Lyon by Italian immigrants to its diffusion throughout the provinces of metropolitan France. A feat of technical achievement, French faience draws inspiration from multiple sources, including decorations indebted to Italian maiolica, Asian porcelain, and contemporary engravings, with forms that derive mostly from European ceramics and silver. The intricate interplay of influences results in pieces of great originality, and the technical complexities inherent in their production heightens appreciation for the craftsmen who magnificently fashioned the impressive examples in the Knafel Collection—the finest collection of French faience in private hands. The quality of such masterpieces almost obscures the fact that French faience was essentially a provincial art, largely patronized and commissioned by a local aristocracy and made far from the centers of political power in Versailles and Paris.

NOTES

1. For the techniques of ceramics, I have relied largely on entries on ceramics, earthenware, and hard-paste porcelain in Trench 2000, as well as on Gay-Mazuel 2012, 41–49.
2. Wilson 2013, 6; Wilson 2016, 8; Barbe 2016, 8; Wilson 2017, 30.
3. Watson 2001, 47; Wilson 2013, 6–13; Wilson 2017, 29–30.
4. Wilson 2016, 5–6. Barbe 2016, 10.
5. Wilson 2016, 6. Wilson 2017, 11.
6. On faience from Lyon, see Wilson 2003; Bouthier 2003; Leprince 2009, 29–30, 38–40; Leprince 2013, 19; Leprince 2015; Horry 2015; Leprince 2016; Perlès 2016, 102–13; Leprince and Raccanello 2016; Wilson 2017, 22, 461–63.
7. Wilson 2017, 22.
8. Leprince 2009, 29.
9. Leprince 2016, 97–98; and Leprince and Raccanello 2016.
10. On Gironimo Tomasi, see Cameirana 1995; Bouthier 2003; Wilson 2003; Thornton and Wilson, 2: 2009, 546–49; Leprince 2009, 30–37; Leprince 2015; Leprince 2016, 98; Leprince and Raccanello 2016, 1–14.
11. Perlès 2016, 104–5, 108–11.
12. On the Fontana workshop, see Vignon 2009.
13. Leprince and Raccanello 2016, 16–17.
14. Leprince and Raccanello 2016; Perlès 2016, 24–25, 102–5, 108–11.
15. Bouthier 2003; Leprince 2009, 38; Leprince and Raccanello 2016, 15–16.
16. Rosen 2009, 78–79; Leprince 2009, 62; Leprince and Raccanello 2016, 15–16; Wilson 2016, 332–33.
17. On faience from Nevers, see Bouthier 2003; Rosen 2009, Leprince 2009, 29–30, and 38; Faÿ-Hallé 2012a, 68; Faÿ-Hallé 2012b, 81; Leprince 2013; Leprince 2016, 99–101; Leprince and Raccanello 2016, 14–26; Métayer 2016; Wilson 2016, 332–39; Wilson 2017, 22 and 461.
18. Leprince 2009, 63.
19. See note 13.
20. Leprince 2013.
21. Leprince 2013; Leprince and Raccanello 2016, 23–26; Perlès 2016, 30–31; Wilson 2016, 334–37.
22. Perlès 2016, 44–45.
23. Leprince and Raccanello 2016, 20–23; Perlès 2016, 28–29, 32–33.
24. On Denis Lefebvre, see Leprince 2009, 77–87; Leprince and Raccanello 2016, 20; Perlès 2016, 32–33.
25. Perlès 2016, 42–43.
26. Ibid., 38–9, 42–43.
27. Ibid., 78–79. See also Leprince 2009, 228–29.
28. Perlès 2016, 84–85. See also Leprince 2009, 240–41.
29. Perlès 2016, 76–77, Leprince 2014, 162–63.
30. Perlès 2016, 40–41, 57–59, 66–67, 76–79, 84–87. See also Leprince 2009, 206–209.
31. Gay-Mazuel 2012, 65–73; Crépin-Leblond, Gerbier, and Madinier-Duée 2016.
32. Gay-Mazuel 2012, 75. On faience from Rouen, see Gay-Mazuel 2012, esp. 31–39, 65–91; Faÿ-Hallé 2012a, 69–71; Faÿ-Hallé 2012b, 82–83; Métais 2016.
33. Gay-Mazuel 2012, 76.
34. Ibid., 31–32, 75–82.
35. Ibid., 32 and 36.
36. Ibid., 33.
37. Ibid., 38, 76–79, 81, 85.
38. Perlès 2016, 144–45.
39. Gay-Mazuel 2012, 38, 85–89.
40. Ibid., 85.
41. On blue and red decoration, see Gay-Mazuel 2012, 125–32.
42. Perlès 2016, 132–35, 142–47, 154–57.
43. Ibid., 146–47, 154–57. On ocre niellé decoration, see Gay-Mazuel 2012, 135–40.
44. Perlès 2016, 180–81, 190–91, 194–95. On polychrome chinoiserie scenes at Rouen, see Gay-Mazuel 2012, 165–73.

45. Perlès 2016, 166–67. On Pierre Chapelle, see Gay-Mazuel 2012, 154–57.

46. Saint-Simon 1840, t. XIII, 109, quoted by Gay-Mazuel 2012, 107.

47. On faience from Moustiers, see Damiron 1919, Gay-Mazuel 2012, 99, 105, Collard-Moniotte 2006, Faÿ-Hallé 2012b, 83–84; Amourdedieu 2016.

48. Perlès 2016, 216–17.

49. Ibid., 218–19.

50. Ibid., 224–25.

51. Ibid., 226–27, 232–33.

52. Ibid., 246–47, 250–51, 254, 256–57, 260–61.

53. On faience from Marseille, see Faÿ-Hallé 2012b, 85–86; Peyre 2016, 273–75.

54. For example, Perlès 2016, 288–81.

55. For example, ibid., 280–81.

56. Peyre 2016, 273, 275. Perlès 2016, 300–301.

57. Perlès 2016, 319.

58. Ibid., 320–23.

59. Ibid., 328–29.

60. On that subject, see Leprince 2009, esp. 176–275.

61. For the function of Rouen faience, see Gay-Mazuel 2012, 107–23.

62. Chilton 2012.

63. Silver or tin was used depending on rank and wealth, with gold traditionally reserved for the royal family and the highest ranking members of the French nobility.

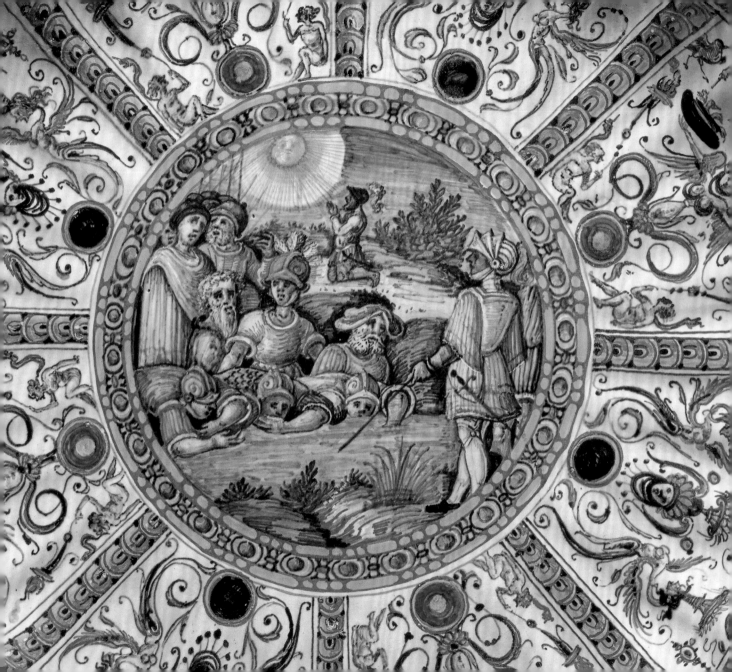

CHECKLIST

Italy, Lyon, and Nevers – Sixteenth and Seventeenth Centuries

1

Plate
Urbino, ca. 1560, or Lyon, ca. 1582–85
If Lyon, painting attributed to Gironimo Tomasi
Inscription: on the reverse, *Mose riprende il popolo e l'eforta!* [Moses reprimands the people and exhorts them]
Diam. 16⅛ in. (41 cm)

2

Plate
Lyon, ca. 1582–85
Painting attributed to Gironimo Tomasi
Inscription: on the reverse, *In columna nubis / israelitas Deus / proecedit / EXOD / XIII* [In a pillar of cloud, God leads the Israelites / EXODUS/ XIII]
Diam. 17¾ in. (45 cm)

3

Dish
Lyon, ca. 1582–1600
Painting attributed to Gironimo Tomasi
Inscription: on the reverse, *Giedeô Selegit cô[n] tra / madian / IVD. IIIII* [Gideon has chosen [in the fight] against Midian / IVD IIIII] Diam. 18⅞ in. (48 cm)

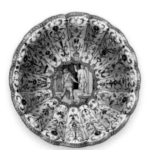

4

Fluted Bowl
Lyon, ca. 1582–1600
Painting attributed to Gironimo Tomasi
H. 5⅜ in. (13.6 cm), diam. 14½ in. (36.9 cm)

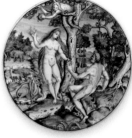

5

Plate
Lyon, ca. 1580–1610
Inscription: on the reverse, *GENESE.III / Adam et Eve* [GENESIS. III / Adam and Eve]
Diam. 10⅞ in. (27.5 cm)

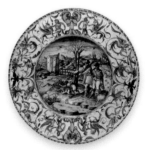

6

Platter
Urbino or Lyon, ca. 1600
If Urbino, attributed to the Patanazzi workshop
Diam. 18½ in. (47 cm)

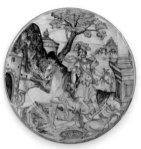

7
Plate
Nevers, 1635
Attributed to Denis Lefebvre
Inscription: on the reverse, *PerSee Et Meduse / 1635* [Perseus and Medusa / 1635]
Diam. 8½ in. (21.5 cm)

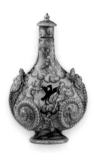

9
Gourd
Nevers, ca. 1640
Attributed to the workshop of Antoine Conrade
H. 17½ in. (44.3 cm), W. 11 in. (28 cm)

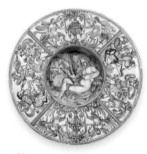

11
Plate (*tondino*)
Nevers, ca. 1640
Attributed to the workshop of Antoine Conrade
Diam. 11⅜ in. (29 cm)

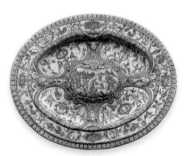

8
Dish (*The Gathering of Manna*)
Nevers, ca. 1630–50
Attributed to the workshop of Antoine Conrade
H. 19½ in. (42 cm), W. 24¾ in. (63 cm)

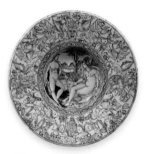

10
Plate (*tondino*)
Nevers, ca. 1640
Attributed to the workshop of Antoine Conrade
Diam. 11¼ in. (28.7 cm)

12
Pair of Covered Vases
Nevers, ca. 1640
Attributed to the workshop of Antoine Conrade
H. 12⅜ in. (31.5 cm), W. 7 in. (17.8 cm)

13

Plate
Nevers, ca. 1645
Workshop of Antoine Conrade
Inscription: on the reverse, *fait a nevers chez Mr di Conradi* [made at Nevers in Mr di Conradi's workshop]
Diam. 18⅛ in. (46 cm)

15

Dish
Nevers, ca. 1640–50
Attributed to the workshop of Antoine Conrade
Diam. 11½ in. (29.3 cm)

17

Gourd
Nevers, ca. 1670–80
H. 17⅜ in. (44 cm), W. 9 in. (23 cm)

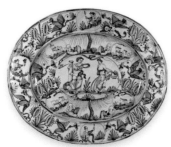

14

Plate
Nevers, ca. 1645
Workshop of Antoine Conrade
Inscription: on the reverse, *de Conradi A Nevers* [by Conrade in Nevers]
H. 16 in. (40.6 cm), W. 19⅞ in. (50.6 cm)

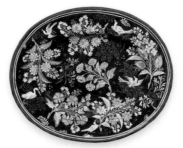

16

Platter
Nevers, ca. 1660–70
H. 16 in. (40.7 cm), W. 19¾ in. (50 cm)

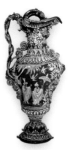

18

Ewer
Nevers, ca. 1680
H. 27½ in. (70 cm), W. 13 in. (33 cm)

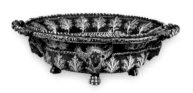

19
Basin (possibly forming a set with cat. 18)
Nevers, ca. 1680
H. 19¼ in. (49 cm), L. 22 ¾ in. (58 cm)

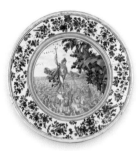

21
Plate
Nevers, ca. 1680–85
Diam. 22⅜ in. (56.8 cm)

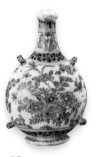

23
Flask
Nevers, ca. 1680–90
H. 11 in. (28 cm), W. 7 in. (17.8 cm)

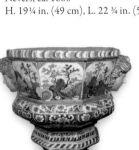

20
Orange-Tree Planter
Nevers, ca. 1680
H. 25 in. (63.5 cm), W. 27 in. (68.6 cm),
D. 21⅛ in (54 cm)

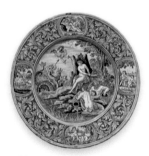

22
Plate
Nevers, ca. 1680–90
Diam. 22⅛ in. (56.2 cm)

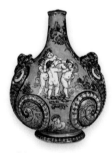

24
Gourd
Nevers, ca. 1680–90
H. 14⅝ in. (37 cm), W. 11 in. (28 cm)

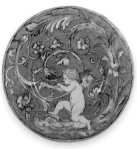

25
Plate
Nevers, ca. 1680–90
Diam. 9¼ in. (23.5 cm)

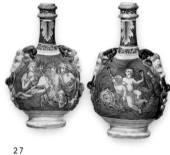

27
Pair of Flasks
Nevers, ca. 1680–1700
H. 13⅛ in. (33.4 cm), W. 8½ in. (22 cm)

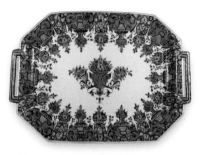

28
Tray
Rouen, ca. 1700–20
H. 12½ in. (31.8 cm), W. 17⅞ in. (45.3 cm)

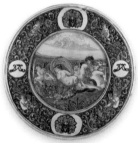

26
Dish
Nevers, ca. 1680–1700
Diam. 18¾ in. (47.7 cm)

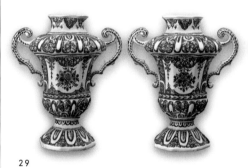

29
Pair of Vases
Rouen, ca. 1710–20
H. 11¼ in. (28.5 cm), W. 9¾ in. (25 cm)

30

Vase
Rouen, ca. 1710–20
H. 7⅞ in. (20 cm), W. 5 in. (12.7 cm)

32

Platter
Rouen, ca. 1725
Diam. 21¼ in. (54 cm)

34

Plate
Rouen, ca. 1725
Diam. 9⅝ in. (24.5 cm)

31

Platter
Rouen, ca. 1710–20
Diam. 21¼ in. (54 cm)

33

Platter
Rouen, ca. 1725
Diam. 21⅝ in. (55 cm)

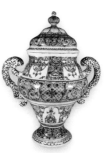

35

Covered Vase
Rouen, ca. 1725
H. 12 in. (31.5 cm), W. 9½ in. (24 cm)

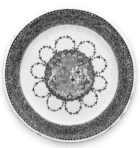

36

Plate with Coat-of-Arms of the Marquis de Saint-Evremont
Rouen, ca. 1725
Diam. 9½ in. (24 cm)

38

Anthropomorphic Pitcher
Rouen, ca. 1730
H. 15⅞ in. (40.3 cm), W. 6 in. (15.2 cm)

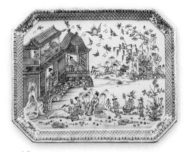

40

Tray
Rouen, ca. 1730–40
H. 18 in. (46 cm), W. 22¾ in. (58 cm)

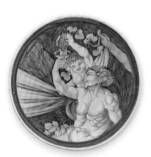

37

Dish
Rouen, ca. 1725–30
Painted by Pierre II Chapelle
Diam. 12 in. (30.4 cm)

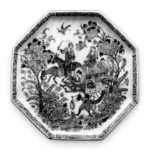

39

Tazza
Rouen, ca. 1730
H. 6¼ in. (15.8 cm), diam. 11⅝ in. (29.5 cm)

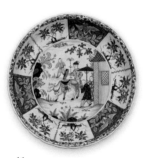

41

Dish
Rouen, ca. 1730–40
Diam. 13 in. (33 cm)

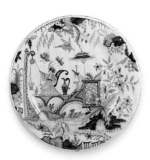

42

Plate

Rouen, ca. 1730–40

Diam. 9¾ in. (24.6 cm)

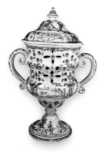

44

Covered Puzzle Vase

Rouen, ca. 1740

H. 12 in. (30.5 cm), W. 7¼ in. (18.4 cm)

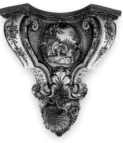

46

Wall Bracket

Rouen, ca. 1740–50

H. 12½ in. (32 cm), W. 12 in. (30.5 cm)

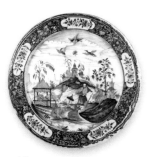

43

Platter

Rouen, 1738

Marks: on the reverse, 1738

Diam. 22½ in. (57 cm)

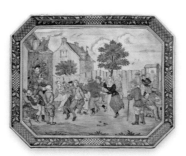

45

Tray

Rouen, ca. 1740–50

H. 17⅞ in. (45.5 cm), W. 20¼ (51.4 cm)

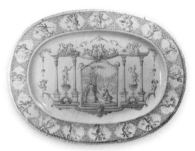

47

Platter
Montpellier, ca. 1730
H. 16½ in. (42 cm), W. 21 in. (53.5 cm)

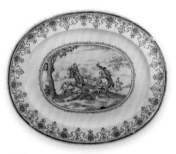

49

Platter
Moustiers, ca. 1700–20
Clérissy manufactory
H. 20 in. (50.8 cm), W. 24¾ in. (63 cm)

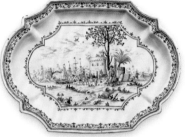

51

Platter
Moustiers, ca. 1730–40
Clérissy manufactory
H. 12¼ in. (31.1 cm), W. 16⅞ in. (43 cm)

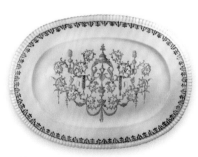

48

Dish
Montpellier, ca. 1730
H. 16½ in. (42 cm), W. 23¾ in. (60.4 cm)

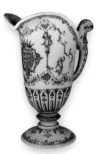

50

Ewer
Moustiers, ca. 1700–25
Clérissy manufactory
H. 10⅜ in. (26.5 cm), W. 9½ (24.1 cm)

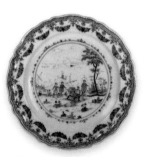

52

Plate
Moustiers, ca. 1730–40
Clérissy manufactory
Diam. 9⅞ in. (25.2 cm)

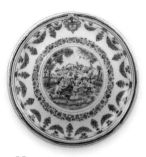

53

Bowl on Foot
Moustiers, ca. 1740
Clérissy manufactory
Diam. 10¾ in. (27.3 cm)

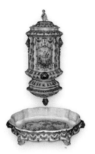

55

Wall Fountain with Basin
Moustiers, ca. 1750
Olérys and Laugier manufactory
Marks: on the reverse, interlaced, *S.OL*
Fountain H. 27 in. (69 cm), W. 10 in.
(25.4 cm); Basin W. 19½ in. (50 cm),
D. 13 ½ in. (34.3 cm)

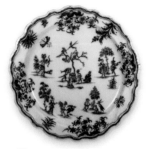

57

Plate
Moustiers, ca. 1750
Olérys and Laugier manufactory
Marks: on the reverse, interlaced, *OL*
Diam. 13½ in. (34.3 cm)

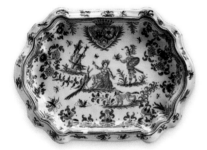

54

Tray with Coat-of-Arms of the Deschamps and
Constant Families
Moustiers, ca. 1750
Clérissy manufactory
H. 7 in. (17.8 cm), W. 9⅝ in. (24.5 cm)

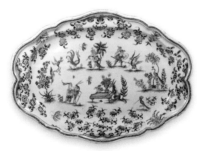

56

Platter
Moustiers, ca. 1750
Olérys and Laugier manufactory
Marks: on the reverse, interlaced, *S.OL*
H. 13 in. (33 cm), W. 18⅞ in. (48 cm)

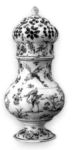

58

Sugar Caster
Moustiers, ca. 1750
Olérys and Laugier manufactory
H. 9⅞ in. (25 cm), W. 3¾ in. (9.5 cm)

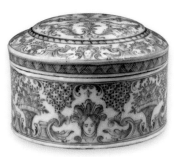

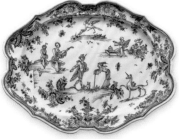

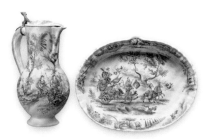

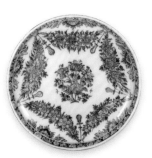

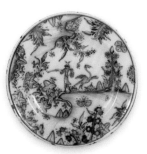

59

Platter
Moustiers, ca. 1750
Olérys and Laugier manufactory
Marks: on the reverse, interlaced,
OL, SC, and *F*
H. 10 ½ in. (26.7 cm), W. 14⅞ in. (37.7 cm)

61

Powder Box
Attributed to Marseille, ca. 1720–30
H. 4 in. (10.2 cm), Diam. 6 in. (15.2 cm)

63

Platter
Marseille, ca. 1720–30
Leroy manufactory
H. 13 in. (33 cm), W. 17⅜ in. (44 cm)

60

Covered Pitcher and Basin
Moustiers, ca. 1760
Féraud manufactory
Basin H. 11 in. (23 cm), W. 14 in. (36 cm)
Pitcher H. 9¾ in. (25 cm), W. 7 in. (17.8 cm)

62

Fruit Dish
Marseille, ca. 1720
Leroy manufactory
Diam. 8⅜ in. (21.2 cm)

64

Plate
Marseille, ca. 1725–30
Leroy manufactory
Diam. 9⅝ in. (24.5 cm)

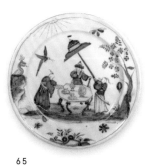

65

Plate
Marseille, ca. 1725–30
Attributed to the Leroy manufactory
Diam. 9 in. (23 cm)

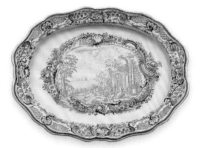

67

Platter
Marseille, ca. 1730–40
Fauchier manufactory
H. 12 in. (30.5 cm), W. 16 in. (41 cm)

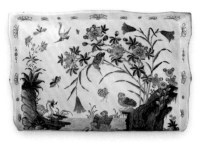

69

Tray
Sinceny, ca. 1740–50
H. 13 in. (33 cm), W. 19⅞ in. (50.5 cm)

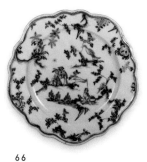

66

Platter
Marseille or Moustiers, ca. 1730
If Marseille, attributed to the
Leroy manufactory
Diam. 13⅜ in. (34 cm)

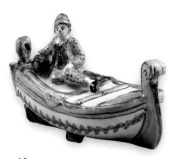

68

Boat-Shaped Spice Box
Attributed to Marseille, ca. 1750
Marks: on the reverse, on either sides of the
rudder, *I* and *P*
H. 3¾ in. (9.5 cm), L. 6¼ in. (16 cm)

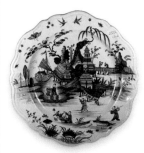

70

Platter
Sinceny, ca. 1750
Diam. 17⅛ in. (43.5 cm)

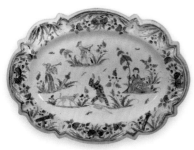

71

Platter
Lyon, ca. 1740–50
Attributed to the P. Mongis manufactory
H. 11 in. (28 cm), W. 15⅛ in. (38.5 cm)

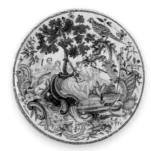

73

Plate
Moulins, ca. 1760
Diam. 9⅝ in. (24.5 cm)

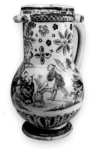

75

Puzzle Jug
Moulins, ca. 1760
H. 8½ in. (21.5 cm), W. 6 ½ in. (16.5 cm)

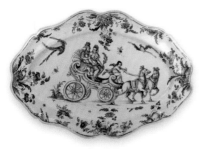

72

Platter
Lyon, ca. 1750–72
Attributed to the de la Borne Feuillée (The
Leafy Bollard) manufactory
H. 12 in. (30.5 cm), W. 17⅛ in. (43.5 cm)

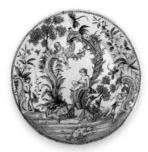

74

Plate
Moulins, ca. 1760
Diam. 9½ in. (24.1 cm)

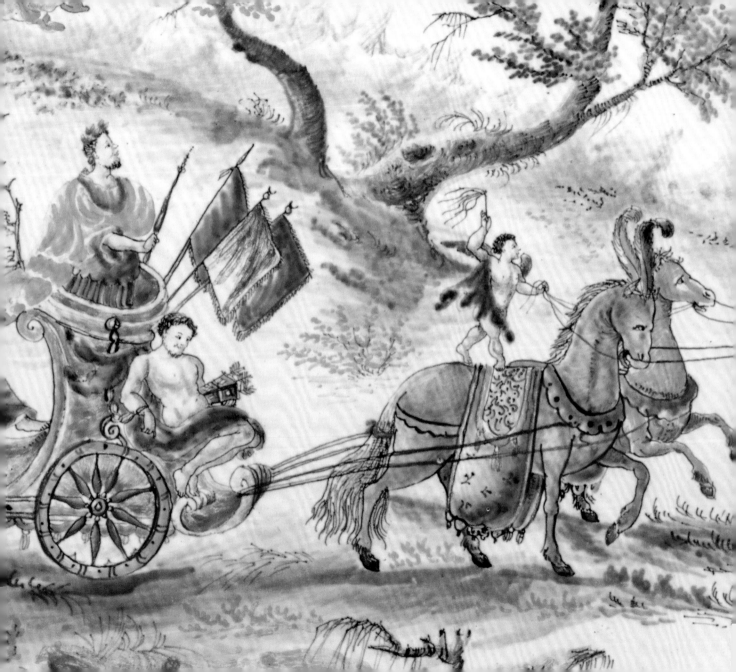

BIBLIOGRAPHY

Amourdedieu 2016
Amourdedieu, Éric. "Moustiers," 209–15. In Perlès 2016.

Barbe 2016
Barbe, Françoise. *Majolique: l'âge d'or de la faïence italienne au XVIe siècle*. Paris: Citadelles & Mazenod, 2016.

Bouthier 2003
Bouthier, Alain. "L'apport des Italiens à l'artisanat d'art en Nivernais." In *Actes du 128e Congrès national des Sociétés historiques et scientifiques, Bastia, April 2003. Circulation des matières premières en Mediterranée, transfert de savoirs et de techniques* (electronic version), 02/2009.

Caiger-Smith 1973
Caiger-Smith, Alan. *Tin-Glaze Pottery in Europe and the Islamic World: The Tradition of 1000 Years in Maiolica, Faience, and Delftware*. London: Faber & Faber, 1973.

Cameirana 1995
Cameirana, Arrigo. "Maioliche decorate a grottesche ed istoriate nella ceramic savonese della seconda metà del '500," 165–70. In *Atti, XXV Convegno Internazionale della Ceramica, 1992, Centro Ligure per la Storia della Ceramica*. Albisola: Centro Ligure per la Storia della Ceramica, 1995.

Chilton 2012
Chilton, Meredith. "The Pleasures of Life: Ceramics in Seventeenth- and Eighteenth-Century France," 23–65. In Williams 2012.

Collard-Moniotte 2006
Collard-Moniotte, Denise. *Comment reconnaître une faïence de Moustiers*. Paris: Réunion des musées nationaux, 2006.

Crépin-Leblond, Gerbier, and Madinier-Duée 2016
Crépin-Leblond, Thierry, Aurélie Gerbier, and Pauline Madinier-Duée, *Masséot Abaquesne: L'éclat de la faïence à la Renaissance*. Paris: Réunion des musées nationaux, 2016.

Damiron 1919
Damiron, Charles. *La Faïence artistique de Moustiers*. Lyon: Veuve Blot, 1919.

Faÿ-Hallé 2012a
Faÿ-Hallé, Antoinette. "French Faience from Its Origins to the Nineteenth Century," 67–79. In Williams 2012.

Faÿ-Hallé 2012b
Faÿ-Hallé, Antoinette. "Faience Manufactory Histories," 81–99. In Williams 2012.

Gay-Mazuel 2012
Gay-Mazuel, Audrey. *Le biscuit et la glaçure: Collection du musée de la Céramique de Rouen*. Paris: Skira Flammarion, 2012.

Giacometti
Giacometti, Jeanne. *French Faience*. Translated by Diane Imber. New York: Universe Books, 1963.

Horry 2015
Horry, Alban. "Céramiques lyonnaises et d'importation provenant des fouilles lyonnaises," 234–35. In *Lyon Renaissance: Arts et humanisme*. Lyon: Musée des Beaux-Arts de Lyon, 2015.

Lane 1970
Lane, Arthur. *French Faience*. London: Faber; New York: Praeger, 1970.

Leprince 2009
Leprince, Camille. *Feu et talent. D'Urbino à Nevers, le décor historié aux XVIe et XVIIe siècles*. Paris: Maison Vandermeersch, 2009.

Leprince 2013
Leprince, Camille. "À propos d'un plat en faïence de Nevers." *Revue de la Société des amis du musée national de la Céramique*, no. 22 (2013): 18–25.

Leprince 2014
Leprince, Camille. *La Faience baroque française et les jardins de Le Nôtre*. Paris: Feu et Talent, 2014.

Leprince 2015
Leprince, Camille. "Le peintre Tomasi et la majolique historiée lyonnaise," 210–17. In *Lyon Renaissance: Arts et humanisme*. Lyon: Musée des Beaux-Arts de Lyon, 2015.

Leprince 2016
Leprince, Camille. "Lyon. The Arrival of Faience in Lyon and Nevers at the end of the Sixteenth Century," 97–101. In Perlès 2016.

Leprince and Raccanello 2016
Leprince, Camille, and Justin Raccanello. "The Transfer of the Istoriato Maiolica Tradition from Italy to France." *French Porcelain Society* 6 (2016): 1–27.

Métais 2016
Métais, Christine. "Rouen," 127–29. In Perlès 2016.

Métayer 2016
Métayer, Pierre-Guilhem. "Nevers," 19–21. In Perlès 2016.

Perlès 2016
Perlès, Christophe (ed.). *French Faïence: The Sidney R. Knafel Collection*. Paris: Mare & Martin, 2016.

Peyre 2016
Peyre, Jean Gabriel. "Marseilles," 273–75. In Perlès 2016.

Rosen 2009
Rosen, Jean. *La faïence de Nevers, 1585–1900*. 2 vols. Quétigny: Édition Faton, 2009.

Saint-Simon 1840
Louis de Rouvroy, duc de Saint-Simon. *Mémoires complets et authentiques du duc de Saint-Simon sur le siècle de Louis XIV et la régence*, t. XIII (1715–16). Paris: L. Delloye, 1840.

Thornton and Wilson 2009
Thornton, Dora, and Timothy Wilson. *Italian Renaissance Ceramics: A Catalogue of the British Museum Collection*. 2 vols. London: British Museum, 2009.

Trench 2000
Trench, Lucy (ed.). *Materials & Techniques in the Decorative Arts: An Illustrated Dictionary*. Chicago: University of Chicago Press, 2000.

Vignon 2009
Vignon, Charlotte. *Exuberant Grotesques: Renaissance Maiolica from the Fontana Workshop*. Exh. cat. New York: The Frick Collection, 2009.

Watson 2001
Watson, Wendy M. *Italian Renaissance Ceramics from the Howard I. and Janet H. Stein Collection and the Philadelphia Museum of Art*. Exh. cat. Philadelphia: Philadelphia Museum of Art, 2001.

Williams 2012
Williams, Elizabeth A. (ed.). *Daily Pleasures: French Ceramics from the Marylou Boone Collection*. Exh. cat. Los Angeles: Los Angeles County Museum of Art, 2012.

Wilson 2003
Wilson, Timothy. "Gironimo Tomasi et le plat marqué 1582 leon du British Museum." In *Majoliques européennes: Reflets de l'estampe lyonnaise (XVIe et XVIIe siècles). Actes des journées d'études internationales "Estampes et majoliques" Rome (October 12, 1996)–Lyon (October 10–12, 1997)*, edited by Jean Rosen, 86–101. Dijon: Édition Faton, 2003.

Wilson 2013
Wilson, Timothy. "Italian Renaissance and Later Ceramics." *Bulletin of the Detroit Institute of Arts* 87, nos. 1/4 (2013).

Wilson 2016
Wilson, Timothy. *Maiolica: Italian Renaissance Ceramics in The Metropolitan Museum of Art*. New York: The Metropolitan Museum of Art, 2016.

Wilson 2017
Wilson, Timothy. *Italian Maiolica and Europe*. Oxford: Ashmolean Museum of Art, 2017.

INDEX

Page numbers in *italics* refer to the illustrations